# VINCENT VAN GOGH

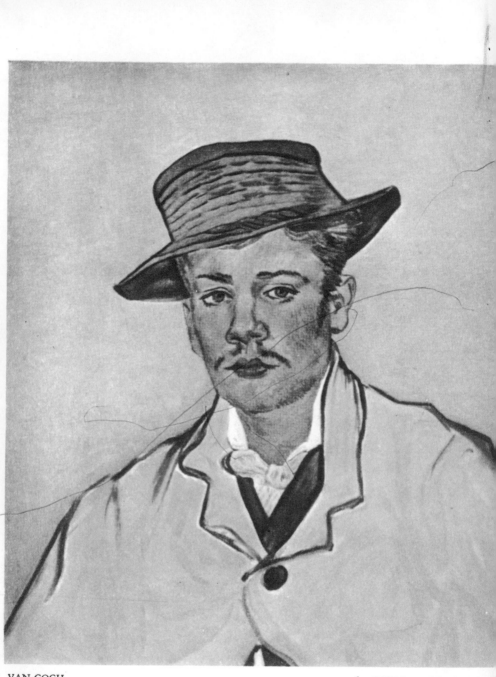

VAN GOGH

1.  PORTRAIT OF YOUNG M

# VINCENT VAN GOGH
## 1853-1890

A STUDY OF THE ARTIST AND HIS
WORK IN RELATION TO HIS TIMES

## By WALTER PACH

*Select Bibliographies Reprint Series*

BOOKS FOR LIBRARIES PRESS
FREEPORT, NEW YORK

First Published 1936
Reprinted 1969

STANDARD BOOK NUMBER:
8369-5095-X

LIBRARY OF CONGRESS CATALOG CARD NUMBER:
78-99666

PRINTED IN THE UNITED STATES OF AMERICA

*To I. E. G.*

who could not look at more than the pictures of the Dutch period on her first
visit to the van Gogh exhibition.

She came back for the others and studied them with the same delight. It is
such understanding of the nature of art, and its value, that has brought van
Gogh out of seemingly hopeless neglect to his present recognition.

# List of Plates

# VINCENT VAN GOGH

## 1853-1890

As I WRITE these lines, a great exhibition of the works of van Gogh is attracting tens of thousands of people to the Museum of Modern Art, in New York. The question is no longer whether to go and see the paintings of the "wild man," but when to go: at what hour one can escape the crowds which, even in those big galleries, prevent one from seeing the pictures.

When the exhibition was first proposed to the committee in charge at the museum, a number of persons objected to it as not sufficiently modern. And there was much reason on their side. The painter had been dead for forty-five years, his work had influenced at least two generations of later artists: surely such a man came more within the province of the museums that occupy themselves with the older arts,—the modern museum exists to deal with matters of our own day. The question is really one of our bad logic in separating art into old and new. The only genuine separation is between the true and the false.

But since we seem to be a long way yet from the courage or the understanding necessary to decide on things as good or bad, and since the confusing word modern still maintains its interest for so many people, we may take sides in the discussion that was presented to the Modern Museum, and I, for one, insist that van Gogh is quite in place there. I do not say so because of his importance as an influence on the art since his day, but because his work has that peculiarly living quality which makes it inexhaustibly modern. As regards various great arts of earlier centuries, it is of the most common occurrence to hear people exclaim—"You'd think that it was done just today!" And van Gogh has already proved himself to belong in this category. Despite a pronounced manner, which is easily recognized as belonging to the latter nineteenth

century, despite an evident interest in searching out the relationship between color and light—a search that was particularly engrossing for the painters of his generation, he is seen, and it is not too soon to say it, to be one of those major artists whom Renoir spoke of as passing beyond the frontiers of their time, as they go also beyond the frontiers of the country where they happen to have been born.

This last consideration, by the way, gives to van Gogh a very timely interest in the America of our day, when people are talking of a national or even local art. Van Gogh was himself conscious of the true character of our period. By his example, doing his greatest work in a country foreign to his own in blood and tradition, as well as by his words (his insight into the increasing community of men's effort—the reverse of the isolationist idea), he showed us that any thought of cutting ourselves off from Europe is as silly as an attempt to cut ourselves off from the past.

To the end, the great lights of art history were his lights, men like Rembrandt—his compatriot, Giotto—so far from him, and Delacroix—only less so (by reason of the Greco-Latin heritage of the Frenchman). And so Maurice Denis is absolutely right in saying that van Gogh never did a thing so absurd as trying to be of his time. But the sheer force of his genius having made him, even so, one of the most characteristic expressions of his period, he is, as I defined him at the first great showing of his work in America, fifteen years ago, the very type of the modern artist. To recall once more Manet's famous pun on his own name, *Manet et Manebit,* he remains (so)—and will remain (so).

▷ Vincent van Gogh was born in 1853 at Groot Zundert, a little village in the Dutch province of Brabant, not far from the border between Holland and Belgium. More than three hundred years before, Brueghel, the first in time of the great Dutch masters, had seen the light near that same frontier, and so the earliest name and the latest in the story of their noble art both attach to the

10

same narrow strip of territory. Both painters travelled far, to lands that led their own in the art-achievement of their day; both belong essentially to their own soil.

The van Gogh family had, for centuries, given men of note to Holland, especially as clergymen and in commerce; in the nineteenth century several members of the family were art dealers. The father of the painter was the pastor of Zundert, himself the son of a highly respected preacher. Three uncles of the painter—his father's brothers, were successful in the art business, one of them being a partner in the great Paris firm of Goupil, which had a branch in Holland, as it later had in America.

Naturally enough, when Vincent and then his brother Theo, four years younger, wanted to go into commercial life, they entered the employ of the Goupil house at the Hague, where they were made familiar with the painting of many Dutch and French artists of their time. The firm was typical of the more conventional aspects of the period and offered a "solid" and saleable type of picture to its international clientele. So that van Gogh's earlier association with art, fostered by the deep respect he had for his family and its business, gave no hint of the rôle of "modernist" that was to fall to him later on. Instead we find him talking with blissful seriousness of men whom the world has entirely forgotten today and whom one cannot imagine as ever enjoying a revival of interest. With them, in his mind, though already on a far higher plane, were the greater moderns who had achieved success, men like Corot and Millet, and then the old masters he knew from the museums of his native land as, later, from the great galleries of Paris and London, when he came to reside in those cities.

The record of his life is contained, above all, in his letters to his brother. Few, if any, artists can be followed so intimately over the whole period of their evolution, and with none do we find a more beautiful relationship than that which existed between Vincent and Theodorus van Gogh. The first known letter from

11

Vincent is dated 1872, the last was written immediately before his death in 1890. Between the two dates the correspondence increased in frequency and interest. The first ten years brought forth over two hundred letters, whereas the remaining eight years saw the writing of twice that many. Their quantity however is a small matter beside their content. For Vincent goes from naïve provincialism to an understanding of that rapidly evolving art of Paris which is the special glory of the time.

To read the letters (and beside those to his brother there is an invaluable volume of his correspondence with the French painter Emile Bernard) is not alone to follow a great man in his personal development, extraordinary as that was; it is to get an insight into the problems faced by some of the leading artists of the day. Supplementing van Gogh's own writing is that which deals with him at the time, especially what Bernard and Gauguin have left us. It is particularly instructive to see certain incidents in the life of Vincent as he relates them, and then as they are recorded by Gauguin. Even when van Gogh had left behind him the mediocre artists he admired in earlier days, we see him as Dutch in his attitude toward the landscapists of Barbizon, and as a romantic in his love for the colorists. Whereas Gauguin, for all his position in the advance guard, remained true to French preference for the masters of pure form—who left van Gogh more or less indifferent. So also, as noted by Bernard, a violent tirade in one of Vincent's letters was drawn forth by the French painter's citation of Baudelaire's famous quatrain about Rembrandt.

But the finest light shed on our painter, from any source other than his own brush or pen, is that of Theo's letters to him. Incidentally, they show anew the noble character of the younger brother, though we need no further demonstration of it than the long-continued financial—and, better yet—moral support which we read of in Vincent's letters. But in those of Theo one appreciates the delicacy with which the aid was rendered—one might better say the unconsciousness of any merit in helping a great

12

man whom he alone, by accident, could judge at his true value. At various times he protests that Vincent more than makes up to him for all he does. The slender volume of Theo's letters contains a few also from his wife to Vincent, and one of the latter, more beautifully than anything else, gives the measure of these men—and of the woman who wrote the lines. Far from home and still a stranger in the foreign city, she thinks of the possibility of dying in the childbirth that awaits her in a few hours. So she takes her pen and writes to her brother-in-law whom she has never seen but who is so real to her through his pictures, his letters, and her husband's words. She tells him that should she not come safely through the ordeal before her, Vincent is to comfort Theo and tell him she was happy because he had done everything to give happiness to her.

Johanna Gesina Bonger, as she was born, the sister-in-law of Vincent van Gogh, as the world will remember her, was of a character which made her in every respect worthy of the rôle she was to play in making the great artist known to the world. When her husband, broken in heart and in health, followed Vincent to the grave, six months after the latter's death, the young widow inherited the hundreds of paintings that remained, practically the whole production of his life, for scarcely anything had ever been sold. The things were considered so utterly valueless, both from the standpoint of money and of art, that she was repeatedly advised to destroy them.

But she already had an insight into the genius of her brother-in-law, her husband having had him in mind constantly and having told his bride (their married life was to last but a year and a half) of the greatness of the man to whom he was sending so important a part of his small earnings. And so she acted not alone to carry out Theo's hopes for the recognition of his brother, but because she knew that in her care was something to rank high in the art-heritage of the world, when she devoted the remainder of her life to the task of winning for Vincent van Gogh

13

the place he deserved. Or to put the matter more exactly, it is to this loyal and clear-minded woman that we all owe not alone the preservation of this art, but its dissemination throughout Europe and America.

To have bestowed the pictures upon the numerous members of the painter's family and her own would have kept the circle of his beneficiaries to a very small radius. It was necessary to have the paintings go out into their own world and reach the people able to appreciate them—the artists first of all, who were to be so powerfully influenced by van Gogh, and then the public of the exhibitions and museums, where the work is assuming a constantly greater importance.

After the pictures had begun to make their way, Mrs. van Gogh-Bonger addressed herself to the literary production of her brother-in-law. If value as a writer was utterly absent from his mind when he wrote those hundreds of letters, it is our right to use the word literature in regard to things which contain so much of beauty. In any number of instances they repeat in words the sensations we get from his painting; and in their ensemble they constitute one of the most eloquent and moving records of an artist's life that the world possesses.

At first, as with the pictures, the task seemed a hopeless one. Well-disposed publishers spoke of the impossibility of finding a sufficient public for the three solid volumes which the letters make up. They asked for a selection, but Mrs. van Gogh-Bonger would always say "Oh no, every letter has interest; we will wait till it is time to publish all of them together." Time was fighting on her side, and Vincent's. First in Holland, then in Germany, then in England and America, the letters appeared—the English translation, down to letter No. 652, on which she was engaged at the time of her death in 1925, having been made by herself.

And so she must have part of the monument she raised "To the Memory of Vincent and Theo" as the simple phrase stands on the page where she dedicates the book, adding the words of the Bible, "And in their death they were not divided."

14

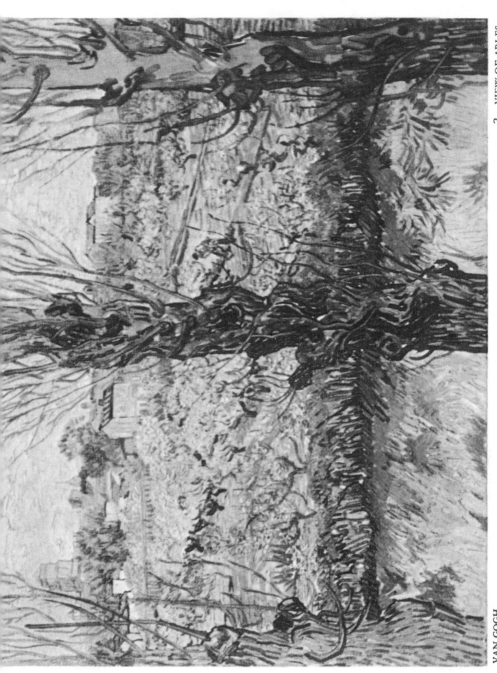

It is worth while to think of the immediate family of van Gogh and of the love his brother gave him through the long years. So much has been written about the misery of artists and his own in particular that we need to see the consolation he had, the work itself being, of course, his chief one. Indeed, as we look today at his glorious production, the career of this man, who often lacked food, who knew grievous bodily and mental ills, defeat, despair, and suicide at last, becomes a series of triumphs. To go from the dark but splendid painting of his earlier period to the full diapason of his latest work is to know that he tasted success for which any artist would pay any price.

From the material standpoint, his case is indeed a painful one, and, aside from material matters two circumstances render it even worse. First, there is the continued ignoring of his art, and it goes on for many years after his death; second, are his difficulties in personal relationships. Twice in his life he hoped to marry, only to find, in each case, that the lady's affections were already bestowed. And when, partly out of pity over the misfortunes of the poor creature from whom he made the famous drawing called *Sorrow*, partly through need of love, he takes the model and her children to live with him, she turns out to be of such a character that the relationship has to end miserably. Always prepared to side with the lowly, van Gogh defends her to his family, who had been sore troubled over the connection. It is as a Christian who takes literally the teachings of his Master about our relation to sinners that Vincent exclaims "She has never seen what is good, so how can she be good?"

If we find no real love from a woman in this life, the story of van Gogh's friendships gives but little more encouragement to those who hope to come on something of ordinary human happiness in his lot. It is clear that he had an immense fund of sympathy, but his unbending principles and his impatience made him difficult as an associate. A man still in the art business tells of the time when he was one of van Gogh's fellow employees at Goupil's and they would go on Sunday for walks in the country near Paris.

15

On one such occasion, having noticed some grapes hanging over a wall beside the road, he picked a bunch and began to eat them. Van Gogh upbraided him so violently for what he called a theft, that the other was constrained to drop the grapes to the ground. The incident is trivial enough, but the importance given by the man to small matters of right and wrong, is an earnest of his whole conduct. There was no middle ground for him, from the beginning to the end, as one sees in his last letters to Bernard. His tone there (and he is discussing the work of a very young man, one of his few friends), is as unrelenting as it had been with the clerk in the art gallery, ten or fifteen years before.

Such harshness—and he applied it to himself in even fuller measure—is not the coin with which one buys a pleasant journey through the world. We see the effect of his temperament in the dramatic story of his relationship with Gauguin. That artist, when van Gogh knew him in the 'eighties, was far from being the master of the Tahitian period which has made his fame. But the young Dutchman is ready to see the enormous talent of his friend, and prevails on Theo to do what he can at the gallery for the man who has spent all his savings in the pursuit of art.

Vincent even obtains from his brother the money for Gauguin to travel to the south of France where he is to live in van Gogh's house and so begin a communal life, which our painter sees as the great need for artists. It is with a sense of human brotherhood that he signs himself merely "Vincent" in his pictures, and he is as eager to share his artistic resources as the money from Theo, which was, perforce, but modest in amount. What should have touched Gauguin more deeply still was van Gogh's readiness to follow him in his work. Every artist is susceptible to that greatest honor of having a brother craftsman accept his lead. And van Gogh was nearing the height of his powers when he did the series of masterpieces known as *l'Arlésienne* which are based on a drawing by Gauguin.

Yet the asperities of Vincent's character and his violence in insisting on his ideas continue during the visit he had longed for, and a

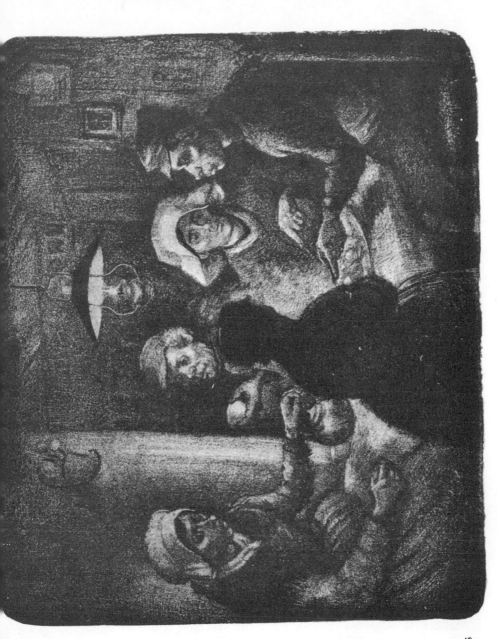

3

POTATO EATERS
(LITHOGRAPH)

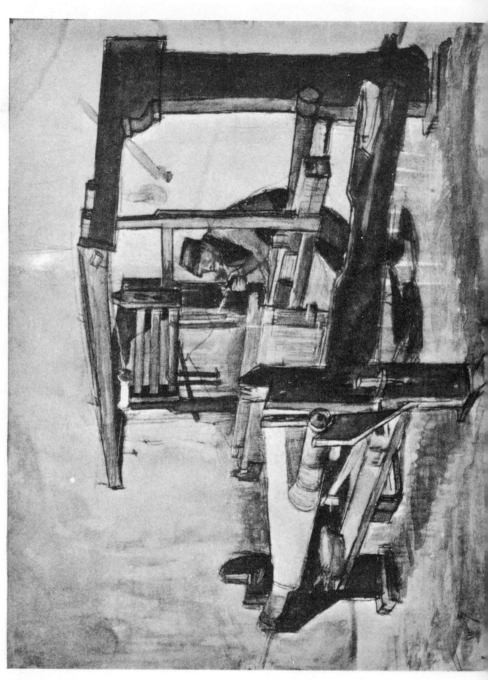

AT THE LOOM

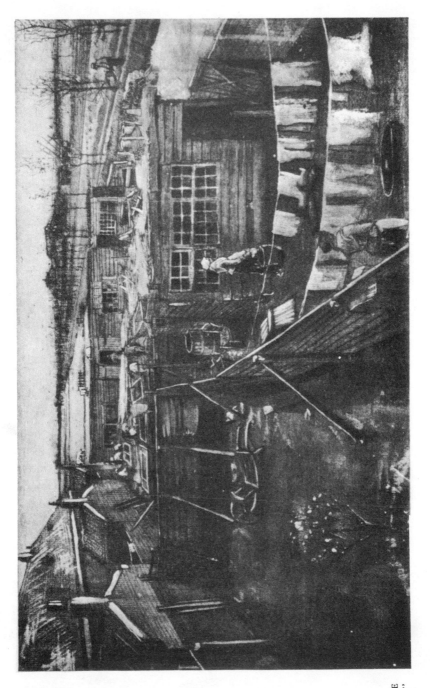

5

BEHIND THE
"SCHENWEG"

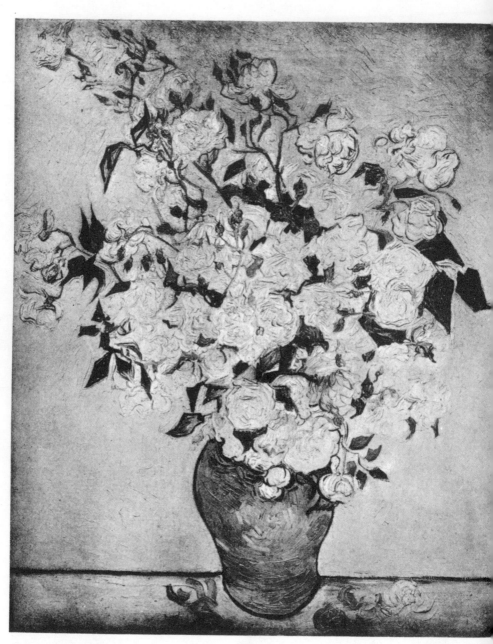

WHITE ROSES

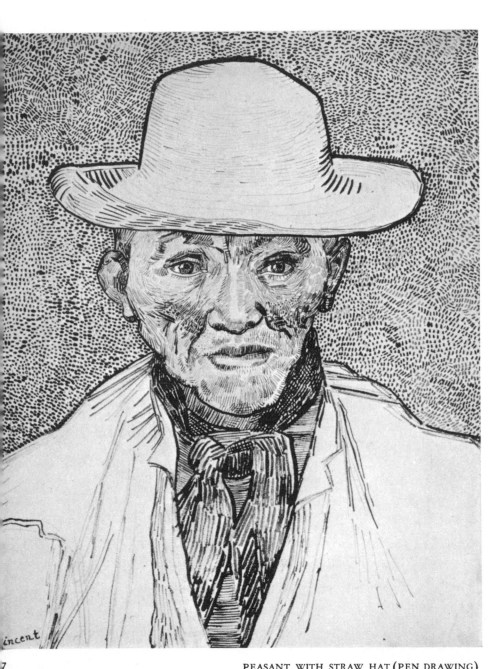

PEASANT WITH STRAW HAT (PEN DRAWING)

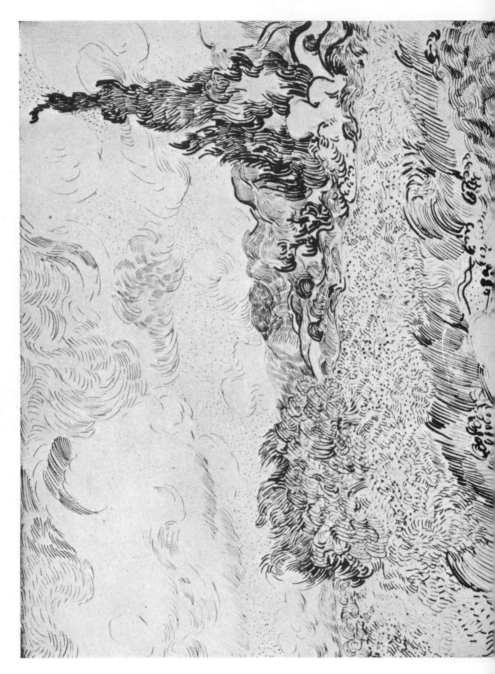

8

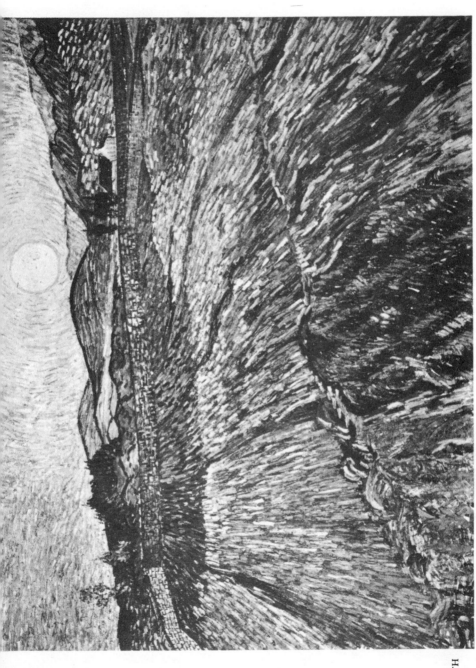

WHEATFIELD WITH
SETTING SUN

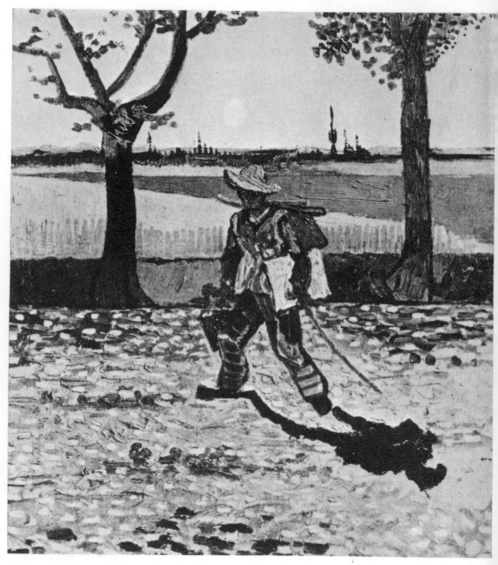

10

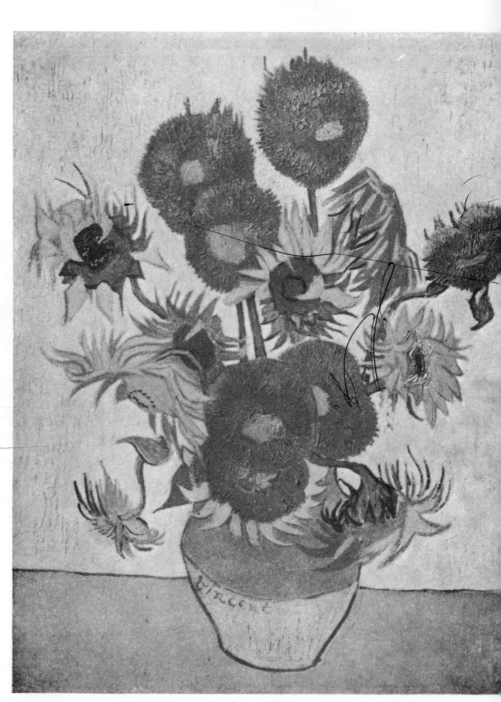

VAN GOGH

11. SUNFLOW

tragedy ensues. One can not, by any means, hold Gauguin blameless in the matter. He was deeply indebted to both of the brothers for their kindness and, finding Vincent's health and nerves shattered by excessive work, he might, for all the harsh and jealous egoism of his nature, have been more considerate of the friend whose unselfish admiration was still to follow him after their separation, and after the outbreak of cruel mental disorders.

Indeed the first of them occurs now, and a man less generous in spirit than Vincent might have looked on the witness of his misfortune as its cause. Any such idea would, however, have been unjust. Troubles as obscure as the nature of the malady itself had doubtless been accumulating in his brain and their explosion might have been provoked by some other incident than that last nocturnal discussion with Gauguin. The latter's very coolness spurred van Gogh to an excitement which abated only in appearance when he finally retired to his room. There, his mind went on in its exasperation until, seizing a razor, he cut off one of his ears. It was with the knowledge of such capacity in himself for wild excess that, feeling the menace of new disorders, he finally took his life rather than go on with the too uneven fight against his odds.

Few people would today venture to see van Gogh's "madness" in his work. It was a thing of occasional, even momentary seizures, and in the long intervals between them, his words are of the soberest, most penetrating intelligence. Notably enough, the other Dutch painter of the first rank in the nineteenth century, Jongkind, was touched with lunacy. It was of a harmless kind, unlike that of another great artist, Meryon, who was dangerous in his insanity. I have suggested in another place that these men, abnormal in the ordinary affairs of life but producing works of the highest artistic value, are proof that we must divide mental processes into some sort of strata, and recognize the sure fact that derangement of some faculties in a man may leave the other ones—indeed the most important ones, perhaps—quite unaffected. If van Gogh's state is to be called madness, even at its worst moments (and it may have been no more

17

than a form of epilepsy, a terrible excitation of otherwise logical sensibilities), the work itself still holds its place among the achievements of art.

The true biography of a painter is to be found in the story of his inner life, above all in the evolution of his idea of art. But before reaching this, in van Gogh's case, we needed to know something of his contact with the outer world and above all, to convince ourselves that the incidents which have served as the base for sensational writing about him were such as might have occurred in the life of any man whose strength had been gnawed through by privations and the demon of work.

It is time to resume the story of his career, which we had followed from the parsonage where he was born to the employment he entered at the age of sixteen. After six years he was dismissed from the Paris house for minor irregularities, such as making an unauthorized visit to his parents in Holland. Commercial life was not for van Gogh, and he enters a divinity school, to follow in the footsteps of his father and grandfather. The severity of the studies which he pursues for four years, the amount of time devoted to the dead languages, are too much for a nature on fire with its faith and eager for service to mankind. So he makes another break with his past.

"He will remain 'humble' and now wants to become an Evangelist in Belgium," writes Mrs. van Gogh-Bonger in the brief biography that introduces the letters and is surely the best guide to the painter's history. She quotes Vincent's good mother, a woman deeply in sympathy with her difficult son, who wrote at the time "I am always so afraid that wherever Vincent may be or whatever he may do, he will spoil everything by his eccentricity, his queer ideas and views of life." And his father adds "It grieves us so when we see that he literally knows no joy of life, but always walks with bent head, whilst we did all in our power to bring

18

him to an honorable position! It seems as if he deliberately chose the most difficult path."

Now he has set forth upon it, and with such impatience that even the three months' course for lay preachers at the school in Brussels is too much for him, and he goes to live among the miners of the Black Country, the coal region called the Borinage. Residing in the house of one of the workers, seeing the hardship of their lot, and himself acting with heroism when one of the terrible explosions of fire-damp brought death and danger to the men he preached to, he feels that words are too weak to express the poignancy of his sense of the world, and he sets himself to render it with pictures. For years drawing had been a means of adding clearness and force to his letters, and each new missive to kind Theo, about the middle of 1880, gives further proof that with drawing, and then painting, he has found his real work at last. He thinks back to his years in the art galleries and asks his brother or his former chief at Goupil's for etchings and reproductions to copy. He compares passages in the Bible and Shakespeare with the effects of the painters. And now the artists of line and color mean more to him than the masters of the spoken or written word.

The first drawings we know of his are already personal, and to be related to the work of his latest days. And from the first, also, we see him as the man conscious that feeling, unaided, will not carry him to his goal. He procures books from which to learn the drawing of the figure, and then sees that he can do it better by going to a city where there are facilities for art study.

Brussels shows him pictures again, after nearly two years in the unkempt mining country, and gives him artists to talk to. The hotel where he pays $10 a month for a room, with coffee and bread three times a day, seems expensive to the man who needs, above all, the materials for his work—"it is a hard and difficult struggle to learn to draw well—" and he has no time or money to lose. Also he realizes that one does not rise above

mediocrity by despising the mediocrity of other men—whose level, indeed, was not easy to attain. For the rest of his life he has set himself the law of work.

It is a jealous, tyrannous master which will brook no rival, either under pretext of material success, or of human relationships, or even of health. All must, if necessary, be sacrificed—and are. But his first period as an artist does not fully reveal this to him: artists sell pictures, why should he not get the small sums for his work that will let him live? A return to the house of his father in Holland was followed by a trip to the Hague, where he once more meets his old chief at the Goupil gallery. He had copied "again" (and the word is significant) the whole series of sixty *Exercices au Fusain,* and now Mauve, the husband of a cousin of Vincent's and one of the best Dutch painters of the time, considers that the young man should begin to paint. He is launched in earnest, and one sees how well Mauve has counselled when we read in a letter to Theo the summary of the older artist's words, "Vincent, when you draw, you are a painter."

And so for five years, in Holland, the work goes on. It is interrupted by money matters and family matters, but the iron will of the artist and the steady help of the good brother carries Vincent through the long period when the painting of his native land furnished his whole theory of art. Indeed he asks no more than that, except work, from the people and the landscape both of which he knows so well.

But again changes were before him. Early in 1885 his father died, and within a year his mother was to leave Nuenen, the village where the pastor had had his last charge. There a real studio had seen the production of work no less astonishing in quality than in quantity. But, as the family felt, the artist needed contacts with the men of his profession, and so when the old home is broken up, Vincent goes to live in Antwerp. For three months he stays there, hoping in vain to make a living by working for a photographer who was to give him portraits to paint.

20

The search for models had always been a difficult one, embarrassed as he was by lack of funds. In one letter of the time he says, "If I receive money, my first hunger is not for food, though I have fasted for ever so long, but the desire for painting is ever so much stronger, and I start hunting for models till there is nothing left."

They were provided, of course, by the art school of Antwerp, but as Vincent had long since passed the age—and docility— for such a place, he goes once more to Paris, early in 1886. Theo was there and had made an important place for himself at Goupil's, more important, to be sure, in its permitting him to further the work of the young Impressionist school, than for the money that could, as yet, be earned with their works. But he had an apartment where Vincent could live; and, a new experience in an academy having proved unsatisfactory, Theo took a larger place, where his brother had a studio of his own.

Of this period, Mrs. van Gogh-Bonger writes, "Of all Theo did for his brother, there is perhaps nothing that proved greater sacrifice than having endured living with him for two years. For, when the first excitement of all the new attractions in Paris had passed, Vincent soon fell back to his old irritability; perhaps the city life did not agree with him either and overstrained his nerves. Whatever might be the cause, his temper during that winter was worse than ever, and made life very hard for Theo, whose own health was not of the best at that time. Circumstances put too heavy a strain on his strength. His own work was very strenuous and exhausting, he had made the gallery on the Boulevard Montmartre a center of the Impressionists, there were Monet, Sisley, Pissarro, and Raffaelli, Degas who exhibited nowhere else, Seurat, etc. But to introduce that work to the public, which filled the small entresol every afternoon from five to seven, what discussions, what endless debates, had to be held, and on the other hand how he had to defend the rights of the young painters against "ces messieurs," as Vincent always called the heads of

the firm. When he came home tired out in the evening, he found no rest, but the impetuous, violent Vincent began to expound his theories about art and art-dealing which always came to the point that Theo ought to leave Goupil and open a gallery for himself. And this lasted till far into the night, ay sometimes he sat down on a chair before Theo's bed to spin out his last arguments."

When one thinks of the unsaleability of the "modern" pictures before the dealers had built up a market for them with the aid of Zola and other critics, through the tenacity of the artists themselves and the support from Germany and America (where Durand-Ruel had opened his epoch-making campaign in 1885), one can understand how unreasonable Vincent's impatience must have seemed to the patient younger brother, and why his wife (as she was later to be) says that merely to live with the painter was the greatest proof of Theo's love for him. It triumphed over every difficulty however, and until early in 1888, Vincent had the inestimable advantage of living in Paris during one of its great periods. He drew from it the teaching that was to alter the appearance—though not the substance—of his art, in such a fundamental way.

Without anticipating our survey of van Gogh's painting, we may glance at this rich Paris of his time. The young men there, who were his great discovery (for he knew the production of their elders, as he knew the Louvre), were making full use of the freedom that had been won for them, especially by the audacious work of Manet. That master, who had used the past, or a very broad section of it, as a springboard, had launched the younger generation on its study of light and the rendering of that barely known aspect of nature through color. Even the most classical-minded artists of the time, such as Puvis de Chavannes and Degas, felt something of the new intoxication (it was that, for good or for ill). The excitement was increased further by that delight in modern life for which Manet found such powerful confirmation in the art of Daumier and Constantin Guys.

Frequently it was with only the barest of physical necessities that the artists of the 'eighties went on in their swift advance, but the movement of the time sustained them. And so we see Monet, Pissarro, and Sisley go from one brilliant work to another amidst hardships that would have broken the spirit of less heroic men, while the comrades of their earlier years, Renoir and Cézanne, not only continue to produce in the teeth of a hostile world, but go on to new discovery and achievement, that often baffles the small public they had won for themselves.

The first group to profit by their conquest contains men who understand that real homage to preceding masters lies not in following them, but in continuing their work. And so we get Seurat, and Signac who push onward the theories of the Impressionists. It is from these men, more than from the original group, that van Gogh is to learn. At the same time, artists like Gauguin adopted a course that was largely the reverse of Impressionism. Cézanne's famous definition—"Monet is an eye—but what an eye!"—while telling, in the second phrase, of the admiration he felt for his friend's work, is already a criticism of the purely naturalistic phase of Impressionist painting. Gauguin, Emile Bernard and others—to which company van Gogh must soon be added—go beyond the mere organization of the effects of nature, however epic it is made by Cézanne. The lyrical quality in Renoir, deep and classic though it is, meets their needs even less.

The word "expressionist," coined in Germany, is not inapt in describing their purpose, which in the realm of poetry may be connected with the Symbolist school of the time. Gauguin, making his sojourns in Brittany, painting the famous *Christ Jaune* where peasant women kneel before a wayside crucifix as primitive as themselves, and Bernard, fervent in his Catholicism and contributing, soon after, to *L'Ymagier*, a review which set itself to bring art back to the rendering of ideas, its function in the old prints of the common people, were both of them evidently, at a far remove from such painting as builds merely on the sensations of

the eye. More important than these men, though only later to produce his chief works in color, was Odilon Redon who, for a quarter of a century, had been bringing forth the magnificent etchings and lithographs in which he told of the world of the mind.

So that with three great avenues to explore—that of the classics, feebly represented in the schools but strongly continued by men as diverse as Puvis and Cézanne, that of the realists with their love of nature's light, and that of new seekers after an inner illumination, van Gogh finds himself in a maelstrom of activity offering the greatest contrast with the quiet he had known in the Low Countries. His powerful mind is quick to grasp the essentials of the art around him and, did we not know the dates, it would seem incredible that he could have advanced as he did in the brief space of two years.

At the end of that time, to rebuild his health, in part, but doubtless even more to find mental repose, he goes to the south of France. At Arles, where he establishes himself, he finds light and color suited to the high-keyed palette of the Impressionists, and he exclaims that the country is as beautiful as Japan. The word is an echo from another type of image-making that had come to mean much to him in Paris.

The color prints of the Japanese artists had been growing in popularity among French painters from the days of Ingres onward. Manet had shown them hanging on walls that he painted, and had approached their flatness through his lighting of the people in his pictures. Van Gogh goes still further in that direction, both in figure compositions and in landscapes, such as those with the flowering trees he found in the South—reminiscent of the cherry-blossom prints of Hiroshige.

And so the ideas he was developing in Paris go on unbroken, and he enters a new period of intense production. When brother Theo's money has all been spent for the paint that he uses so lavishly, he continues his work with India ink and a brush or a

reed pen, noting that he had already used the medium in Holland, but that the reeds he finds in the Midi are better than those he had before.

He works with an energy unusual even for him, during those first months at Arles. He delights in the beauty of the South and its people—who carry on something of the Greek type brought there by the far-off ancestors who colonized the country and built its exquisite temples. But soon Vincent needs again the companionship of artists. It was not simply a personal loneliness, but had to do with his idea of modern art and its new direction. He writes to his brother that he is having a share in the French Renaissance that the painters of his generation are creating through their new discoveries. But the scientific advances of the time were not enough, and he says:

"The *necessary, indispensable* pictures to make present-day painting completely itself, and to carry it to a height like that of the serene peaks attained by the Greek sculptors, the German musicians, and the writers of the French romances, *go beyond the power of an individual,* and will probably be created by groups of men combining to execute an idea held in common." To this Emile Bernard adds, "Eager to bring scattered talents together in a unified effort, he explains that one man has a masterly orchestration of color, another has grand and beautiful drawing, a third possesses an imagination that could establish surprising compositions."

He tries to get Bernard to come to Arles, but the younger man is prevented from doing so. It is then that he addresses himself to Gauguin, who accepts—with the results that we have seen. After the crisis provoked by the ill-starred attempt to create the nucleus of an association of artists working in common, Theo, who had hastened to Arles, keeps in touch with the patient through the doctor, the Protestant clergyman, and Vincent's faithful friend Roulin, the postman, whom we know from several portraits.

In two weeks Vincent was able to leave the hospital, but he was

25

badly shaken, and the morbid curiosity that the townspeople show him was the worst irritant for one who had gone through his painful experience. Attacks of mental disturbance return, he is tortured with the thought that the scene with Gauguin and the loss of his plan for a community of artists is due to some fault of his own. After fighting off until May, 1889, the menace of renewed dementia, he voluntarily enters the asylum at St. Rémy. There he remains for a year, in the most dismal company, with only one doctor—and perhaps not the most sympathetic one—as a friend. But he can work freely and he does so, within the institution, or in the town, or outside it in the wheat fields and the olive orchards or, going further still, he paints the distant peaks of the lower Alps. With a steady rise of his powers, he reaches the highest point in his career at this period, as we see in such a culmination as the *Raising of Lazarus*.

His letters at this time, while touched by the sadness of his surroundings and containing terrible allusions to the neurotics and lunatics among whom he lived, are still those of a man of active and powerful mind. His logic, whether applied to matters of general interest or to the problems of his profession, was never more clear. He sees deeper into the Bible, and writes of its meaning for his favorite artists, like Rembrandt, Millet and Delacroix. His criticism of the painting of Bernard, who continues to send on work for him to see, is brilliant in its impartial penetration.

Meanwhile he had built up new reserves of physical strength and could trust himself to return to Paris unaccompanied. City life would have meant too violent a change after the quiet of the South he had known for two years, so Theo found for him a place to stay at the village of Auvers, near the capital. Daubigny had lived at the place and, later in the century, Cézanne and Pissarro had painted there. Good Dr. Gachet, a friend of Cézanne, who was to be Vincent's companion and safeguard, was deeply interested in art, and worked at it himself as an amateur.

At first everything seemed propitious. The short stay in Paris, the joyous reunion with Theo, and seeing the dear new sister-in-law

26

with her baby, to whom the old family name of Vincent has been given—mainly for the sake of the artist, all is as the brothers would have wished. Not the least of their happiness, one may be sure, came from the sight of the work which the artist had been sending so regularly from the South. His first masterpiece, *The Potato Eaters,* from the old Dutch period is there, but what an advance is represented by the later pictures! Theo has long since known that the idea he would credit only on sufficient evidence is true: his brother is a great artist. And for Vincent himself it must have been a real event to see his pictures assembled in that cosy dwelling to which the young wife had brought some of the sense of a home that came to her so strongly from her native Holland.

But evil days, with threats of new seizures for Vincent, were not far ahead; indeed, the final tragedy comes within two months, at Auvers. Work had been resumed where it had been interrupted but a short time before at St. Rémy. And the letters follow the even tenor of their way, with a clear-eyed seeing of the art of the time, with speculations as to the union of artists that he had meditated so long, and with observations on his old calling, the art business, that Theo carries on in his wise manner. Gauguin has written again and Vincent answers. He writes his mother of the things which led to his departure from St. Rémy. There is no hint of anything less than perfect lucidity in these last weeks, though a last, unfinished letter, dating from the day he shot himself, mentions a threatening mental crisis.

For those who have credited the story that his suicide was decided on in order to relieve Theo of the burden of his support, it is comforting to read a passage from one of the very last letters; it has to do with a time when the little namesake, to whom his heart goes out so warmly, has been seriously ill. He had hastened to Paris in order to be with Theo, and the latter had told him of the problems which constantly assailed him in the firm. Vincent was, as always, in favor of Theo's getting out and founding a gallery of his own, though

the outlook for the modern men was still so difficult. Then, speaking of some lines he had just received from his sister-in-law, he wrote:

"Jo's letter was really like a gospel for me, a deliverance from the anxiety caused by those hours I shared with you and which have been so heavy and bad for all of us. It is no small thing when we all see our daily bread in danger. It is no small thing when we feel how precarious is our existence. When I came back here, I felt terribly depressed, and I felt hanging over myself the storm which threatens you. But what should one do? See, I am trying to keep up a good mood. But when my life is attacked at its roots, my steps become uncertain.

"I feared, not very much, but yet a little, that I was laid as a burden upon you, but Jo's letter proved to me clearly that you both feel that I also am working and am taking pains, even as you do."

So that Theo, who had so often declared himself well repaid for everything, has now conveyed his faith to his young wife, and the sufferer can die in peace on this score at least. He must have known the greatness of his work, and in the last letter that he sends to Theo, one has the satisfaction of hearing him say that the picture he has just done of Daubigny's garden is one of his strongest. He is weak only through the treacherous attacks on his mental health, and it is a thing independent of his art and of the support of his brother that brings him to his end. Theo survived it for only six months. Never very resistant, physically, he was struck down by the death of Vincent, beside whom he was buried at Auvers.

With the baby, Johanna van Gogh-Bonger returned to Holland, and, throughout the thirty-five years she had still to live, remained faithful, as we have seen, to her great heritage. When her son published his father's letters to Vincent a few years ago, he gave to the world what is probably the final document in the history of this noble family.

And now to see the inner record of Vincent van Gogh's life, for his essential story is not that of the miseries through which we have

followed him; it is written in the splendor of his art. A parallel with the last years of his greatest compatriot is almost unescapable, for in the case of Rembrandt there is the same contrast between the circumstances in which he died and the glowing achievement that came out of such darkness.

One can indeed carry the comparison further back, for the painter of the seventeenth century, like the painter of the nineteenth, struck out from the narrow confines of the art around him, and it was because of his demand for deeper spiritual values in painting and for a wider technical range that Rembrandt incurred the hostility of his public and lost its financial support. Van Gogh might have become one of the prosperous artists of whom modern Holland has had a number, had he not been driven on by the fire of his ideas and by the realization of the superior attainment that the French owe to their broad tradition.

Yet it would be the greatest mistake to underestimate the value of the painting that surrounded van Gogh in his youth. Jacob Maris, Mauve, Breitner and the rest of their company retained something of the sense of nature which makes the landscapists of seventeenth century Holland the greatest in the world. It is, to be sure, with a heavy and often unimaginative painting that the modern Dutchmen resume the history of their school, which had almost completely decayed in the eighteenth century. The connection between its classics and its latter-day representatives is often very difficult to see.

Yet in one case, that of Jongkind (1819-1891), it is unmistakable and splendid. Few people know the works he produced before coming to France, where most of his life was spent. But, like van Gogh's early painting, the things of his youth are purely Dutch, differing in personal talent and not in general conception from the pictures of the men around him. I have in mind one of Jongkind's early landscapes, painted in the grays and browns of his school and period. But one chief reason for the delight it gave to its purchaser was, as he said, its striking resemblance to a certain picture of land and sky by Rembrandt. There was indeed the same sense of the

grand spaces of the lowlands, and it was sustained by a curiously parallel arrangement of diagonals in the lowering clouds. So that one need not be surprised, on looking into Signac's admirable book on Jongkind, to see that painter reproduce Rembrandt's famous etching of *Six's Bridge* and with it a plate by the modern Dutchman.

The audacious but authoritative comment of the writer is that "Both are in the same tradition to such a degree that it seems difficult, without consulting the signatures, to differentiate between the two Dutch masters. Are they not, with analogous subjects, in an almost identical technique, that of a painter, and of a great painter? And perhaps that of Jongkind is the finer of the two!" We have already remarked a likeness of history between the two great Dutch artists of the nineteenth century in the fact of their mental aberrations. Let us observe in passing that their records run parallel through the influence that both receive in France—and then the influence that both exert on the later men of the country to which they repaired. For, if so much of the painting since van Gogh's day has built upon his art, all the great Impressionists were directly and deeply indebted to Jongkind, who was by twenty years their senior.

But to return to the men who remained purely Dutch in their painting, Jozef Israels, whom van Gogh refers to so often in his letters, may well be the modern painter who meant most to him in his early years. And, if a production too well suited to the materialist side of the nineteenth century, too sentimental at times, too opaque in the matter of color and soft in the matter of form, has left with many an idea of Israels as an artist of minor importance, there are works by the man, and not too few, which show his prodigious admiration for Rembrandt, his deep study of the master's effects, and the fine use he made of the influence of his idol. Both on the technical and the human side, Israels was a guide whom the younger man could follow with profit.

Something should be said also, in looking back to van Gogh's youth, about the high level of art-appreciation that obtained in nineteenth century Holland. If people there were not as quick as

the Germans to see the greatness of the latter-day masters, one needs only to think back to the little museum into which the painter Mesdag converted his personal collection in order to recall what treasures of Corot, Delacroix, Rousseau, Millet, and Courbet were in Dutch possession. The brother-in-law of Theo van Gogh, Mr. A. Bonger, was one of the first admirers of Redon, and owned a number of notable works by him, by Cézanne, and others among the best artists of the time.

As for the Old Masters, it goes without saying that in a family as interested in art as were the van Goghs, and amidst the magnificence of the galleries of Holland, Vincent would come to a love of them as easily as he would learn to read and write. I will give but one instance of what they meant to him, the one contained in an account we have from a friend who accompanied him on a trip to Amsterdam, during his time at Nuenen. When they went to the Ryksmuseum, "Vincent could not tear himself away from the *Jewish Bride* by Rembrandt, and said at last, 'Do you know, I would give ten years of my life if I could sit here before this picture for a fortnight.'" Frequent references in his letters tell us of his love for the other old artists of his country.

And, if this might be assumed as a matter of course, one is not so prepared for his extending his admiration to various modern men whom one can not easily think of after the giants. The explanation resides, I believe, in the lateness with which van Gogh adopted painting as a profession. He had always loved it, and done something with drawing, as an amateur, and so, with a natural longing for skill, was ready to give too broad a credit to the men who had gone through a thorough schooling and could handle the difficult and complicated technique of the craft. On the other hand, Jongkind, a born painter, and with an uncanny mastery of the resources of oils, water color, and etching, was, like van Gogh again, consistently indulgent to inferior artists. "There is good in it" was his comment on even a decidedly poor picture; so that the thing denoted, by the

31

likeness of attitude in the two artists, was probably a similar generosity in their spirit.

Here, also, we come back to the fact that the painting both of them grew up with in Holland was provincial, and the demands they made were not as severe as those which Parisians would evolve amid the wealth of sensations in the world capital, with its competition and its criticism. Drawing, as practiced in Holland, was a simple, naturalistic study, free from the complications of classical tradition that obtained in Paris ateliers—in the earlier nineteenth century, with its memories of Louis David and Ingres more than today, when the great heritage of pure form has weakened. The other great aesthetic property was allowed by the modern Dutchmen to depend on faithfully observing local color. The brown of the seashore, the gray of the sky, the green of the dune-grass were set down without thought of much more than naturalistic probability as to relationships—by all save the two geniuses of the school. As if to reveal its deficiency, Jongkind and van Gogh become colorists of first importance, the former, in his own day, being as remarkable in this respect as van Gogh in his freer time. Aware of the difference in viewpoint between the two periods, Vincent remarks that a certain painter is not so much a master of color as of tone. The last word doubtless signified for him that harmony which may be had in a black-and-white; or it may appear in a painting where a generalizing glaze is applied to draw together conflicting hues—a procedure that the real colorist avoids, or uses with the utmost economy.

But the observation quoted from our painter just above, dates from the last months of his stay in Holland. During his earlier years there, before his mind had turned to Delacroix for guidance, he would hardly have felt the distinction. To note this development of his perception is not simply to look forward to the progress which awaited him in France, it is to see how comfortably he could fit in with the dark painting he saw about him during his first period. It is often but little removed from a negation of color, considering the quality in the sense that the Impressionists have made general for

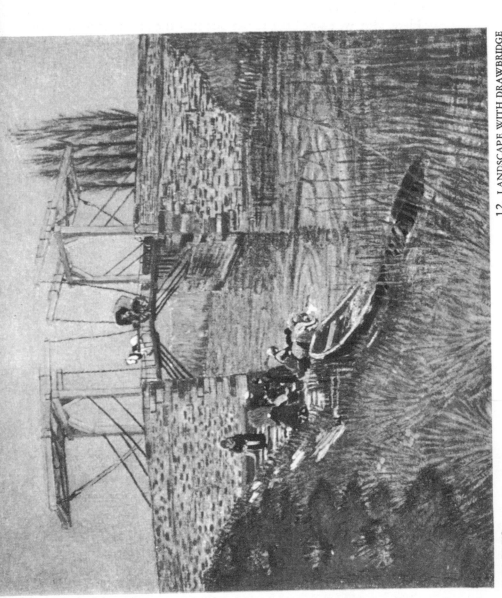

VAN GOGH

12. LANDSCAPE WITH DRAWBRIDGE

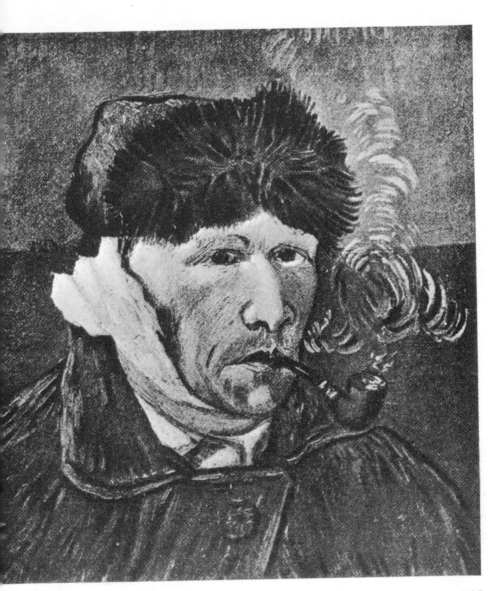

3

SELF PORTRAIT WITH PIPE

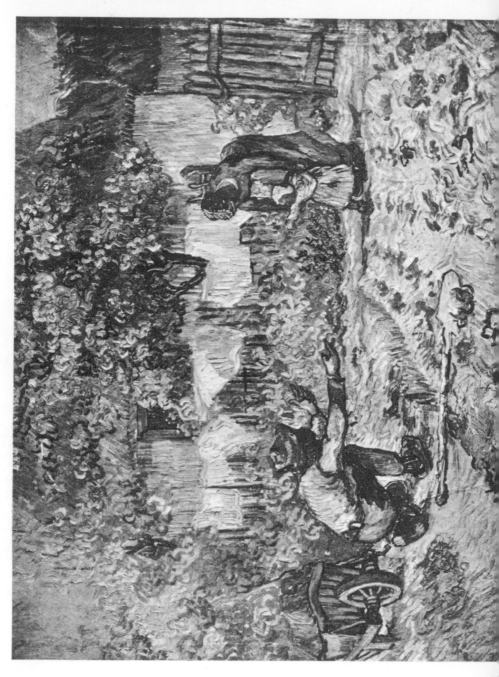

14

THE FIRST STEP
(AFTER MILLET)

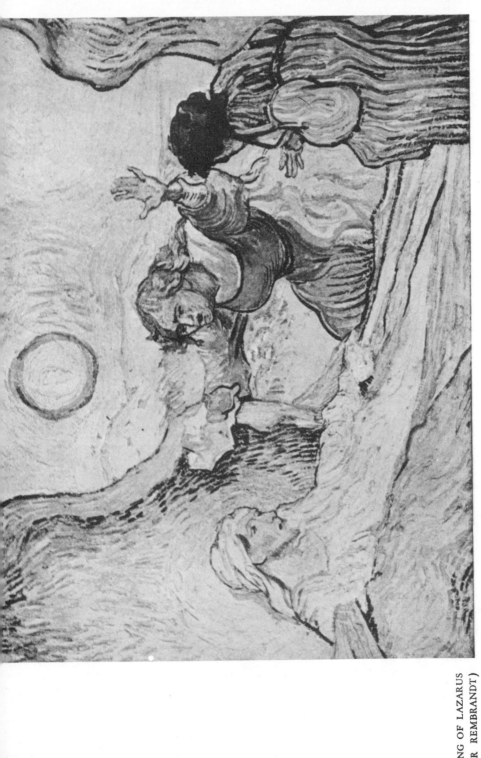

RAISING OF LAZARUS
AFTER REMBRANDT)

THE TRESTLE

CITY GARDEN
IN ARLES

18

L'ARLESIENNE (BY GAUGUIN)

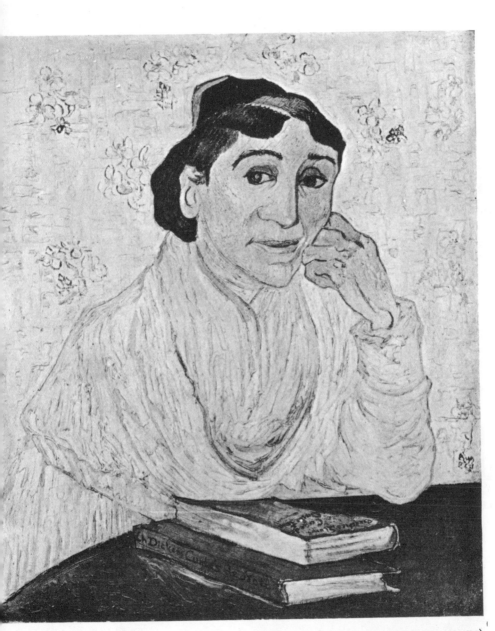

L'ARLESIENNE (AFTER DRAWING BY GAUGUIN)

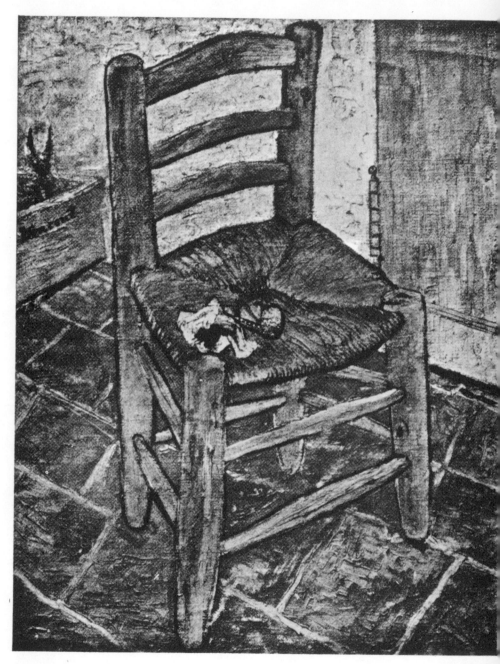

CHAIR AND PIPE

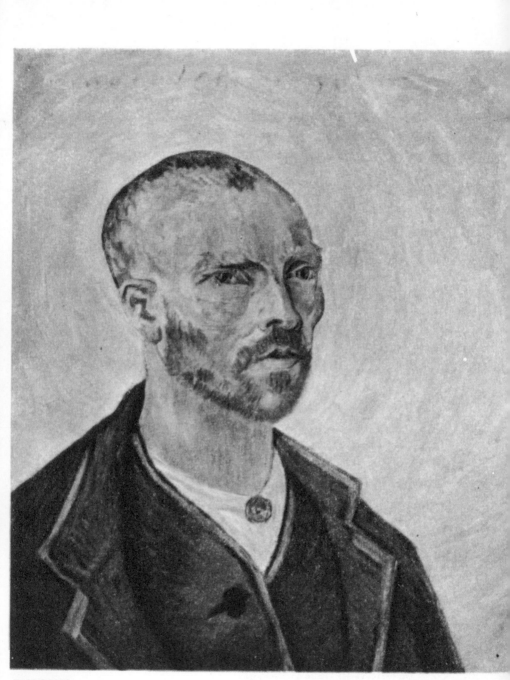

VAN GOGH

21. SELF-PORTRAI

our time—the Orient's knowledge of color being too far away, and the wonders of the Venetians, of Rubens and even of Delacroix (so near in time) being as yet understood by only the rarest people. Even today the properties of Ruben's color are too often thought of as similar to those of Jordaens or van Dyck, and one hears the names of Watteau and Pater, or of Delacroix and Decamps uttered in one breath.

What distinguishes the great Fleming from the men around him, just as it takes away any real similarity between his two inheritors (the one of the eighteenth century and the one of the nineteenth) and the men who imitate them, is not simply greater personalities in the case of Rubens, Watteau, and Delacroix: it is an immensely superior understanding of the science of color—for science it is, even if no one has been able to give a generally acceptable statement of the laws which govern it. Instinct seems to be still our necessary approach to these laws, though with the true colorists the instinct gets to a point of infallibility, or all but that.

Van Gogh knows that such certainty is needed to complement the emotional side of his art, and there are continual references in his letters to his desire to get a firm basis for his painting.

"I do know who are the original and most important masters, around whom, like round an axis—the landscape and peasant painters will turn: Delacroix, Corot, Millet and the rest. That is my own opinion, not correctly formulated.

"I mean there are (rather than persons) rules or principles or fundamental truths for *drawing,* as well as for *color,* to which one comes back, when one finds out an actual truth."

Some months before (in 1884) he had come on a passage in one of Charles Blanc's books that gave him Delacroix's idea on a matter of capital importance, especially as it reports a conversation which took place only three months before the master's death. Charles Blanc had maintained that the great colorists are those who do not use the local color of objects in their painting.

"Eugene Delacroix took two steps backward as was his habit and.

33

half-closing his eyes, said, 'That is perfectly true. There is a tone, for example, (and he pointed to the dirty gray tone of the pavement), well, if you said to Paul Veronese: Paint me a beautiful blonde woman whose flesh shall have that tone,—he would paint it, and the woman *would be a blonde* in his picture.' "

It is almost amusing to learn that one reason why van Gogh liked Ziem was because that painter had been a friend and early defender of Delacroix's. The idea gleaned from the master haunts Vincent, and goes far toward explaining why he can so quickly grasp the theory that color is the result of relationships when, later on in Paris, he finds Georges Seurat, above all, drawing new consequences from such logic. At the Ryksmuseum in Amsterdam, while his mind is so much occupied with these matters, Vincent notes with excitement that not only the great Italians and the modern French have known these principles, but that the old masters of his own land have built on them. Do we not have a sure prophecy of the expansion his color will assume in France when we find him exclaiming at the way the yellow costume in a Frans Hals picture brings out the violet tones in the flesh?

The truth is that van Gogh's constant study results merely in confirming and not creating his instinct for color. Perhaps in his early time, the force of this instinct could not be understood by even the people most in sympathy with him, perhaps not even by himself. But in view of the triumphs of his later painting, there must be no mistake about the born colorist who is before us in that first master-piece, *The Potato Eaters*. Painted at Nuenen after repeated studies of detail, many of which still exist, its limited range of color succeeds in rendering not alone the full solidity of objects under the light of the lamp and amid the atmosphere of the room: it already gives a deep account of that sense of the beauty of color for which the artist's work with the clearer and more varied palette of his maturity will furnish testimony that is more arresting and indeed stronger, but not really different. Other works of the Dutch period, ones with a wider range of color, even if containing less of the dramatic appeal

of *The Potato Eaters,* offer still surer proof that the quality of his painting is native with him, and not acquired.

Two scraps of conversation come to my mind at this point. Having once rather thoughtlessly spoken of the artist as belonging in part to the French school, I was met by a simple but pithy comment from his nephew, Vincent W. van Gogh, "So? Well, I think he is always Dutch." And then I recall what Matisse said when, after the settling of his father's estate, he came once more into possession of his first picture, which he had not seen for some thirty years. It had been done in a provincial town, without instruction, and without so much as awareness that a "modern" school existed. Yet on seeing it he told me that his first feeling was one of profound discouragement, that it seemed as if he had made no progress whatever. He had done so, to be sure, and van Gogh made progress— at a fantastic speed; but it is essential to realize that the real artist builds on a character, a vision, that is his from the first.

If there is difficulty in doing so in the presence of van Gogh's color, with its metamorphosis from darkness to light, the oneness of his art is easy to grasp when we consider it from the standpoint of form. In this respect, Vincent changes but little, save in the matter of skill, a thing that naturally comes with incessant practice. From the first work we know to the last, his drawing is directed to the rendering of character and expression. His study of modelling is pursued with the vision of the realist who wants his work to give the effect of nature with a maximum of conviction. And even such detractors as he may still find today will admit that he does impose this conviction, that he carries out the idea he got from Millet and copied out for Theo in a letter: "I had rather say nothing than express myself weakly."

In van Gogh's early years, there are many drawings where feeling is allowed to predominate over the ability to render appearances, in others one sees him try to depict nature in quite objective fashion. Both phases of the work grow stronger, especially when his schooling at the Hague and his opportunity to work, at Nuenen and then in

35

France, permit him more freely to release the images that form in his brain. But the expressive side of art is always to the fore with him: a conception of form as something beautiful in itself cannot be traced anywhere in his work, to the best of my observation and that of others. Had such an idea become clear to him, one could scarcely find him, as one does, speaking in praise of an inferior artist like Lhermitte. It can only be the latter's taking the peasant as his subject that causes Vincent to place him with his great idol among the artists of the later time. "When I think of Millet or of Lhermitte, I find modern art as great as Michael Angelo and Rembrandt." Millet, with all his emotional quality, remains a draftsman and a colorist; Lhermitte's painting is scarcely more than what Russell Sturgis used to call book-illustration on a glorified scale. And the distinction between the two types of men resides precisely in the sense of form as an aesthetic property. Van Gogh misses this in his appreciation of other men's art, and it seems to me to be but a minor factor in his own art.

It would be unfair to judge him on the strength of letters dating from 1885 in which he comments on Theo's enthusiasm for the Poussins in the Louvre. As Vincent says, he has not seen Poussin for a long time and so the great classicist's purity is not sufficiently present to his mind to keep him from another (and, this time, not less than absurd) comparison with Millet and Lhermitte. If we pass by this as an effect of his early training, it does give us a start, on reading his letters from Antwerp, to find him so much of two minds about Rubens. The portraits appeal deeply to him, but when he comes to the great compositions in the cathedral, his admiration for the technical accomplishment is not proof against his romantic objections to the rendering of character, for which, after citing Rembrandt, he uses words such as "hollow, pompous, yes—altogether conventional, like Jules Romain and worse people of the decadence."

His placing of Rubens is right enough from a chronological stand-point, but only insensibility to the classical values of design—both of form and of color—can explain the judgment quoted just above

When we think of the marvels of color van Gogh was himself to produce later on, we must still consider them for their expressiveness. And having traced the singleness of concept that obtains throughout his life, we may again turn to *The Potato Eaters* and his words about that picture, for an account of his ideas.

"I am getting on with it, and I think there are quite other things in it than you ever can have seen in my work. At least so distinctly.

"I mean especially the life. I paint this *from memory on the picture itself*. But you know yourself how many times I have painted the heads!

"And then I run over every night to hit off some details on the spot.

"But in the picture I give free scope to my own head in the sense of *thought* or imagination, which is not so much the case in *studies,* where no creative process is allowed, but where one finds in reality the food for one's imagination, in order to make it exact. . . .

"It is the *second* time that a saying by Delacroix means so much to me. The first time it was his theory about colors, but afterwards I read a conversation he had with other painters, about the making, viz.: the *creation* of a picture.

"He maintained that the best pictures are made from memory. *Par coeur!* he said. And about that conversation, I read that when all those honest people had gone home in the evening, Delacroix with his usual vivacity and passion loudly *called after them in the center of the boulevard, 'Par coeur! par coeur!'* probably to the great astonishment of the respectable passers-by."

It is very important to see such ideas appearing in van Gogh's mind at this relatively early stage in his career. Applying perfectly to his latest work (and less than a year before his death he will paint a masterpiece from a reproduction of one of Delacroix's pictures), we get a renewed sense of the unity of his art from lines like the foregoing. Again from the many passages in the letters about his first great work, we find the artist defining, in his own words, a tendency of his drawing that will hold good throughout his life. *The Potato Eaters* having been sent to Paris and Theo having

written of showing it to Charles Serret, Vincent replies to the comments of that admirable artist:

"Tell him that my great longing is to make those very incorrect-nesses, those deviations, remodellings, changes of reality, in order that they may become, yes, untruth if you like, but more true than literal truth." An observation elsewhere in the letters gives the reason for this. Speaking of a painting he says, "But there is a certain *life* in it, perhaps more than in some pictures that are absolutely faultless."

If he takes a concept as hard to define as life for his criterion in determining what is really the truth in art, he does not depart from the principle we previously heard him state,—that drawing and color have laws. And as with his lifelong study of the science of color, so we find him persistently at work to discover what makes rightness of form. Again Delacroix appears as his mentor, offering him the theory that the best drawing results not from a following of the outline of an object but from the use of ovoids that render it from its center. Noting the effect of this practice in Delacroix's great friend and model, he writes, "With Géricault the figures have backs, even when seen from the front," and he declares that the theory comes down to us from the Greeks.

It will easily be seen that this type of drawing, directed above all to producing a sense of volume, would be sympathetic to a man whose final ideal is Rembrandt and the other masters of his realistic school. Immediately after the citation concerning Delacroix's nocturnal vehemence, he gives some words of Charles Jacque's: "I assure you that your Mr. Ingres is nothing but an image-maker, and that Daumier surpasses him infinitely."

The issue is joined. Not for van Gogh is the perfection of line that Ingres held to throughout nearly eighty years of ceaseless work. The sculpturesque Daumier with his prodigious mastery of character is as preferable in Vincent's eyes as he was in those of Jacque. And having noticed him, at the end of his life, painting from a print after Delacroix, we may recall that there is a superb work of his last year after Daumier also, while the picture which may possibly

38

be the greatest of his life, *The Raising of Lazarus,* painted just before his departure from St. Rémy in 1890, is composed of figures taken from Rembrandt's etching of the subject. It goes without saying that in these cases and the numerous ones where Millet has furnished him with figures and landscape, there is no faintest hint of a pastiche. Not merely is the color entirely invented by him, but the drawing is as free and personal as if done from nature. In reality one should see this group of magnificent paintings as but another testimony to the idea, almost incessantly present in the letters, that works of art are as much reality as are human beings and objects.

But it is time to pause in the unmixed admiration with which we have been approaching this work. We do not want to look for defects in it (at its best it has none—like the work of the masters in general). But the range of art is wide, and to treat Ingres as an "image maker" bespeaks a lack of concern with certain of the great qualities of art. The question is evidently not one of drawing, since Daumier (almost exclusively a draftsman) is cited at once by Jacque—and van Gogh copies out his words with unmistakable relish. No, it is not Ingres's medium but his character as an artist that leaves the two painters cold. Where, in the letters or the work of van Gogh do we find ourselves referred to the line of descent from which Ingres stems? Where are the names or the qualities of Holbein, of Raphael, of the Greeks? The last-named do come in for one important reference, to be sure, and I shall give it presently, but the serenity which all such artists have in common is clearly alien to the passionate spirit of our painter.

One need feel no regret in stating that van Gogh's work has little of the quality of form that marks the greatness of the classical school. Indeed, if we would get the enjoyment that the museum can offer, there is no bigger mistake than to ask of an artist the sensations which men of another race or period alone can give. The means by which Cimabue produces his awesome effects are unconnected at a single point with those of the not less important art that Rubens gives us. If the crassness of my juxtaposing those two men seems to

call for an apology, I can give one only to the extent of saying I was provoked into making so obvious a point by people who prove they have never considered it when they long for Raphael in the presence of van Gogh.

The perfection of Holbein is not open to him (who once asked how one could be calm in a fencing bout). But again and again he does finally bring calm out of the antagonistic elements in his pictures: the lines balance, the colors with which he renders light as no painter before or since has done, reach absolute harmony; not a touch in the work could be changed. In short, he has attained his own type of perfection. It is that of the Romanticist, achieving his success through intensity of effort and feeling, not that of the Classical artist, eliminating impurities until his work is of an unclouded harmony. That may be said of a marble from the Parthenon, as full of life and movement as it is; it can scarcely be said of even so sublime a work as Rembrandt's *Syndics*. For if the picture be in reality as irreproachable as it seems to most of us, it yet carries with it memories of the Inferno that the artist has traversed.

To come nearer to criticism of van Gogh, or rather to define through the matter of form, which we have been observing, the sensations that distress us in the presence of some of his work, it does tell, frequently, of a fire in the man that scorched the observer as it did the artist himself. Years ago I wrote that his symbol is flame, and its mark is seen with increasing vividness as his life goes on. In certain paintings and drawings of cypress trees, dating from the St. Rémy period, the corkscrew movement of lines and masses seems almost consciously intended, though we may be sure it comes merely from a mental gesture which has become automatic. In the best works, the flame-forms take on directions that complement each other. Examples of this are the astounding *Wheatfield with a Setting Sun* in the Kröller-Müller collection and, even more, *The Ravine* (not the Kröller-Müller version, but one in a German gallery).

40

These pictures, for all their dynamism, attain perfect balance. This is often done by transposing from one place to another lines or colors that form a compensating scheme, somewhat as the musician varies his use of a theme by the process called *rubato*. At other times, however, the movement seems to get out of hand, and the effect is one of tortured rhythms that destroy all sense of repose.

Again we have a thing that is characteristic of van Gogh's art from its beginning to its end. Only, with the slenderer structure of form and color in the early works, their contrast between stable and unstable balance is to be seen more in the matter of their emotional content. In some, there is not less than grandeur in the seizing of character, in others the work leans toward the grotesque, the incomplete, or even the deformed. He has a right, however, like all artists, to be judged by his best work, and in it he renders his vision with simple lines and masses that are the more appealing because of the artist's rapt absorption in his subject. This is typical of him throughout his life, but it is particularly suited to the peasant themes of the Dutch period, where the humility of the models is matched by the spirit of the man who portrays them. But even in these years, when he is on the ground he knows best, there is excess which leaves the work harsh and thin at times, the flame sinking low for want of sustenance, while in later life it devours itself as its passion goes beyond control.

It is rare for the color to show this defect. Van Gogh had the instinct for it from the first, as we have seen, but on reaching Paris he perceived so well the superiority of the color comprehension which he found there that he set himself with humility to acquire the science worked out by the French. He was not less humble in the matter of drawing, as will be seen from a passage of Emile Bernard's. It is in the preface to the volume, published by Vollard, of Vincent's letters to the French artist, who writes:

"I see him yet at Cormon's studio, in the afternoon, when the school, emptied of students, became a sort of monk's cell for him; seated before a cast from the antique, he copies its beautiful forms

with angelic patience. He is eager to possess those outlines, those masses, those reliefs. He corrects himself, begins again with passion, erases, and finally makes a hole in the paper with his rubber. The truth is that, in the presence of that Latin marvel, he does not suspect the complete opposition between his Dutch temperament and the conquest he wants to make, and he will find his road far better and sooner among the Impressionists, with their free fantasy, and their easy lyricism, than before this calm perfection revealed to serene men, amid civilizations close to nature and to thought.

"How quickly Vincent grasps this fact! And here he is, leaving Cormon's place and yielding to his own nature. He does not think of drawing from the antique, nor, as he had done under the teacher he had temporarily chosen, will he go on painting those nude women surrounded by imagined carpets, the odalisques of some harem veiled in dreamy mists."

No indeed, the wretched formula of academic or merely commercial picture-makers was not for him; and, not having the classical instinct for form which led certain men to persist in the study of the great attribute, even under men unworthy to pass on its tradition, he turns his attention to the young, healthy group whom we have seen before as the influence on his production in France.

At first the schooling they give him, by their example even more than by their words, means work as rigorous in its exactitude as any copying of Greek casts under an old-style draftsman. But a freer expression was soon to come. By the time van Gogh reached Paris, the instinctive analysis of light and color by the original Impressionist group had reached the stage of well-defined principle which permitted Georges Seurat to complete his great picture of the *Grande Jatte* in that year (1886). He was ready to put his principles into words, and it is significant that he and his comrade Signac should have done so, whereas Monet and Renoir, of the earlier generation, were completely averse to such definition, and left art explanations to "professors," while the real men, as they affirmed, got their teaching from nature and the Louvre.

But those two preceptors, their story confirmed by the genius of the men just before, were now represented by a generation whose clearness met with quick response from the eager neophyte from Holland. He understood them, his study of the older schools, together with his years of silent work at home, having pressed down the steel spring of his powerful mind until it was ready to start with a swift release, and to give a continued, implacable drive to the mechanism of his art.

Soon the black-and-white painting only tinged with color, that was his instrument on arriving, is changed by the scientific analysis of the French to a style in which the full range of the spectrum is used. As he was living with Theo during the two years of this wonderful advance, we do not have the week-by-week, sometimes day-by-day record of the letters, which let us date the pictures of his other periods.

But the dates of his work during this time are not difficult to determine from the progression of his painting. The earliest Paris pictures are distinguished only in subject matter from those he did in Holland. It was one thing for him to realize the truth of the principle he drew from Delacroix, that the real colorist must see beyond the local color of objects, it was quite a different matter to apply the idea to his work. For that, as for so many other things, the best teaching is derived from the example of others—from participation in the action of others, as when one learns to dance.

And Vincent found a whole generation dancing. Or to put the matter obversely, but still along the same line of thought, the younger men were acting on the idea that Cézanne formulated in his dictum, "As long as we go from black to white, we flounder." Amplifying this is the observation which that excellent painter and teacher, Paul Sérusier, once made to a student, "My friend, you are falling into the white. Go to Louvre and look at the Titians; you will see that the greatest contrast in his work is not obtained by an opposition of black and white but by the difference between yellow and violet, red and green, blue and orange."

43

Delacroix had based his painting on such study of the Louvre and the confirmation of his findings there which came from his historic sojourn in Morocco. What the example of the Orientals had meant to him in turning theory into practice, the example of Pissarro, Seurat, Gauguin and the other descendants of the great Romantic colorist meant to van Gogh.

At first he seems to realize only that the French pictures are in a higher key than his own, and he "falls into the white," as Sérusier put it, attempting to rid his work of the dull tone he now sees it to have, as compared with that of his new friends. He substitutes color for black, according to the Impressionist theory, and does achieve a type of brilliance that would have satisfied a lesser man. But his inborn need of the whole truth, supplemented by what he saw and heard around him, would not let him stop at this point. Soon we see him following the second part of that advice of Sérusier's, and investigating the effect of one color on another.

Such a procedure is comparable with the great study of the fifteenth century Florentines when they worked out the sciences of perspective, anatomy and chiaroscuro. And the fact that a new addition to knowledge was made along similar lines in our own time gives confirmation to the idea that the nineteenth century is of the same nature as the Renaissance at its height. What was obtained by instinct in the preceding periods is now attained by reason. No one can look, for example, at the color in Fragonard's *Bathers* in the Louvre and say that its marvelous luminosity in the flesh or its perfect limpidity in the shadow of the foliage is obtained by any means other than the color opposition that the science of the later time explains. Had the eighteenth century formulated its knowledge, one could not imagine even the Revolution causing it to be lost as it was when the severe school of David turned away from the wisdom as well as the frivolity of the *ancien régime*. Even while its masters were still proscribed we find the young Delacroix copying Watteau—whom Ingres, also, defended against an upholder of the idea that such painting was unworthy of the modern time.

But if the eighteenth century lived on in the sensibility of these two great artists, the fact remains that the color which the earlier time had known was preserved only by instinct. The nineteenth century studied color as the fifteenth century studied anatomy and chiaroscuro, but it is not at all sure that our new logic will suffice to prevent another eclipse of the quality. For its expressiveness is so dependent on the need of the time that the latter factor, more than the "fundamental truths" which we saw van Gogh meditating in Holland, seem to be the determining influence on our employment of color.

Whatever its future, we know how intensely it was studied in van Gogh's day, and what a culminating point in its analysis had been reached by the time he arrived in Paris. Even so, the two years he spent there were short enough for anyone to grasp and apply the science that had been developing. We learn something of the spirit of the man when we see him, at the age of thirty-three, submitting to the discipline required for breaking up a solid passage of color into its component hues, each one represented on the canvas by a separate touch. That is a far remove from the temperamental brushing with the big rich strokes of his Dutch period.

And the result is different. It is not so much a matter of the wide gamut of color that the artist learns to use in Paris, for we have seen that in the narrow range of his early things he had given unmistakable proof of his talent. But now the talent has at its service an instrument capable of making it fully effective. Instead of the general feeling of the Dutch days, here is knowledge whose increasing precision is apparent as we see Vincent pass from the laborious setting down, dot by dot, of pure pigment, to a joyous use of the clear tone he now attains. There are moments when he pauses in his research, and lets himself have the pleasure of asserting his triumph over the hard technical problem. He goes beyond any student psychology into a mood of jubilant success; the color sings. Yet he does not forget the love of nature that carried him through so many dark years; indeed, some studies of high grass, with each stalk rendered by itself, surpass in accuracy of observation any of the closely detailed

45

drawings of houses and interiors which he (like Jongkind again, in the latter's Dutch period) had pushed to a faithful and loving conclusion.

But Paris and her artists were there to urge him on to always severer analyzing, and he goes beyond notation of color to adaptation. He heightens the blues and greens in the clothing and background of the self-portraits he does, until only the strongest red, vermilion, will suffice to render the russet color of his hair and beard. And though the life in the portrait tells clearly that he is not relaxing his early demand for character, such use of the means to express it denotes the maturing of a new potentiality in his art.

With each color assuming its place in the ensemble, instead of being studied by itself, he reaches the control that a musician has after mastering the character of each instrument in the orchestra. The black of Vincent's Dutch pictures might be compared with the tone of the bass viols, something to give body and resonance but not to drown out the light voice of the oboes and flutes. The "sharp violins," as Dryden called them, and which we may here represent in fancy by the bright yellows and crimsons of the painter, are understood in their dominant rôle of establishing the pattern which the whole of the work must follow. On a few occasions, perhaps under the influence of those fascinating color prints from Japan, it seems as if van Gogh would give up his European heritage of depth and solidity, and be satisfied with a decoration of surfaces to which the light itself seemed to be applying the brilliant color.

But that marks only the extreme to which he has gone in these two years of analysis. The time he had still to live is given, above all, to synthesis. Composition is now a different matter from what it was in the old days in Holland, when a landscape or a human being filled the rectangle of the picture with more or less felicity, but no real variation of color animated the general mass of the tone. Neither is this later period like the student days in Paris, so near in point of time, so far away if considered from the standpoint of the distance he has travelled. Then he was asking what made up the

46

phenomenon of light, how it could be evoked in the beholder's imagination by its components of color. Now he has the knowledge, and at his finger tips, and will use it, freely, as a master.

The new direction is not assumed over night, but it dates pretty accurately from his arrival in Arles. Some trial work goes on in the first months there, and there are canvasses where he resumes the Neo-Impressionists' use of finely divided strokes, as if to assure himself that his instrument is quite in tune. But by the summer of 1888 he is launched on painting that fuses the color again, a certainty as to relationships allowing him to use *one* blue, *one* yellow, where he had needed to restate them in numerous variations but a short time before. His line, also, becomes quicker and more adapted to the form and design. He is ready for a new advance, his goal now being set by the demands of pictorial structure and expression.

For the former of these two elements, Cézanne was doubtless his ideal among contemporary painters; we see in certain works by van Gogh a direct influence from the older man, whose unequalled power, affecting the art of Gauguin also, was undoubtedly recommended to Vincent by his comrade. Though Cézanne's pictures were not generally accessible, enough of them could be seen for the newcomer to realize their importance, and, on one occasion, he took some of his own work to Cézanne for criticism. He got it; but in that explosive form which rendered difficult an appreciation of the master's deep tradition and intellect. The words of Cézanne which have come down to us from the interview are—"To speak sincerely, your painting is that of a madman."

There was, of course, no hint of mental derangement in van Gogh at this time, and the vehement sentence has to do with the method (or, in Cézanne's eyes, the lack of method) of the younger man. As Bernard was to find out when he visited Cézanne, years later— for the benefit of all who have profited by his indispensable account of the master—"Cézanne was absolute in everything."

The word method, as I have used it just before, must include that second element, expression, which van Gogh was developing with

47

his fellow-members of the first Post-Impressionist group. But though Cézanne admired Redon, despite all the "literary" content of the latter's work, he could not accept a man who lacked the sense of classical form that the French painter had developed in his long study of the drawings of Leonardo and others of the Latin descent. It is this which, in Redon's own statement, gives reality to his world of vision, and van Gogh's "incorrections" (to return to the word he used of himself in replying to Charles Serret) had no such base.

It is reasonable to see Vincent's departure for the South as his recognition of a need to carry his art to fuller realization; the question of his health and the difficulties of work in Theo's apartment were factors in bringing about the journey, but more important in the question was doubtless the idea of meeting criticism, like that in the severe words of Cézanne, with masterpieces which should justify his faith in his art. The demoniac intensity of his work in the first months at Arles is mostly to let out the energy he has accumulated from the great impressions of Paris, but in part, too, as he writes, to have things to show to Gauguin when that artist should join him.

There is a story about Vincent's time in the Borinage which I have never been able to verify. It tells that when the miners had given up as impossible the task of rescuing the last survivors of an explosion, the young clergyman, fired with the belief that there are no impossibilities for those who do God's will, went back into the mine nine times, and each time carried out a suffocated workman on his back. *Se non è vero, è ben trovato,* once more. Or let us say that in van Gogh's case we do not need the story of a man doing the impossible under stress of excitement; the point is covered a hundred times more effectively by the character of his painting. There are innumerable cases of men putting forth effort not to be explained on material grounds; there is not another case in all the centuries of art history where a man covers in four years such a development as van Gogh spanned, from 1886 to 1890, in France. To describe his art from a technical standpoint, as one might do with Pissarro or Monet, would

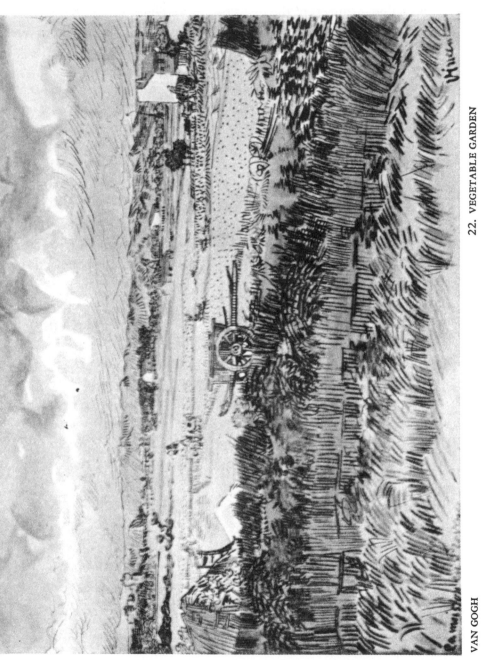

VAN GOGH

22. VEGETABLE GARDEN

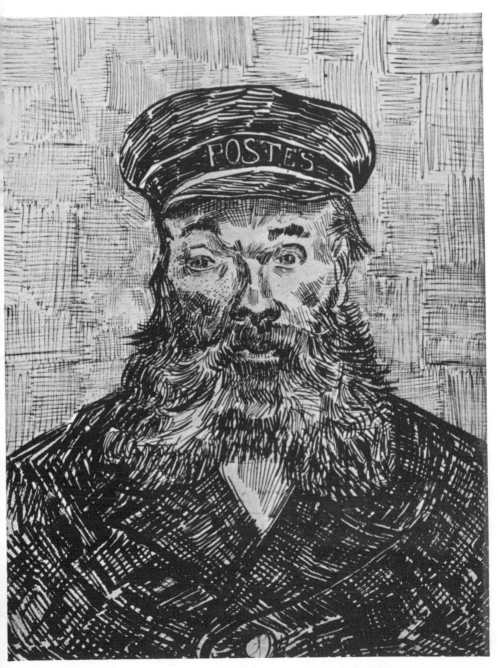

23                                    THE POSTMAN (PEN DRAWING)

THE RAVINE

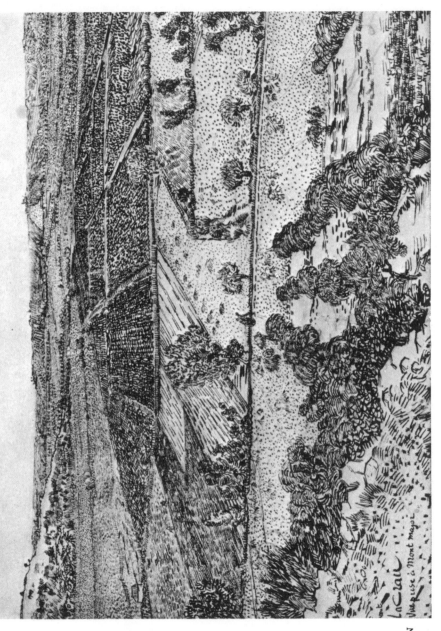

VEGETABLE GARDEN
(PEN DRAWING)

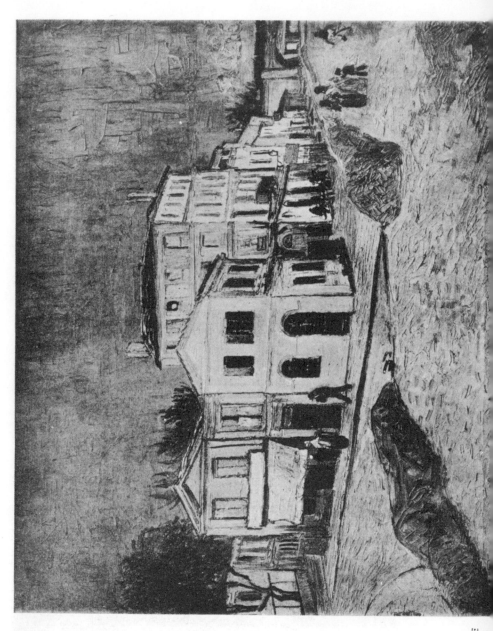

ARTIST'S HOUSE
IN ARLES

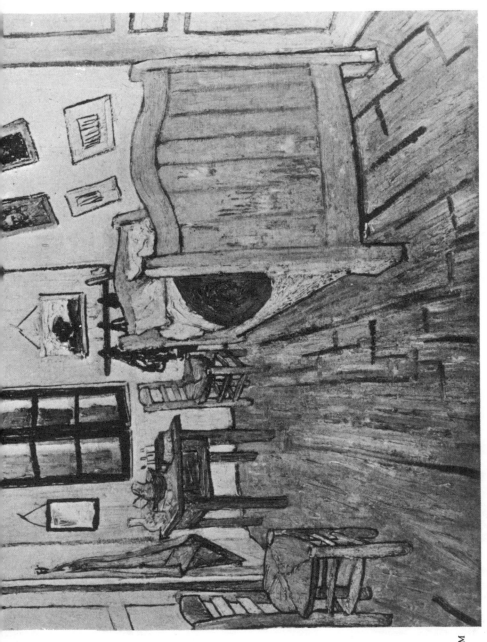

27

ARTIST'S ROOM
IN ARLES

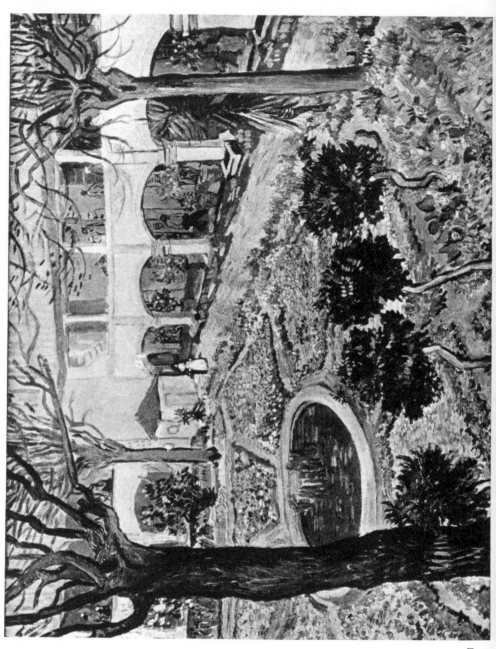

HOSPITAL GARDEN
IN ARLES

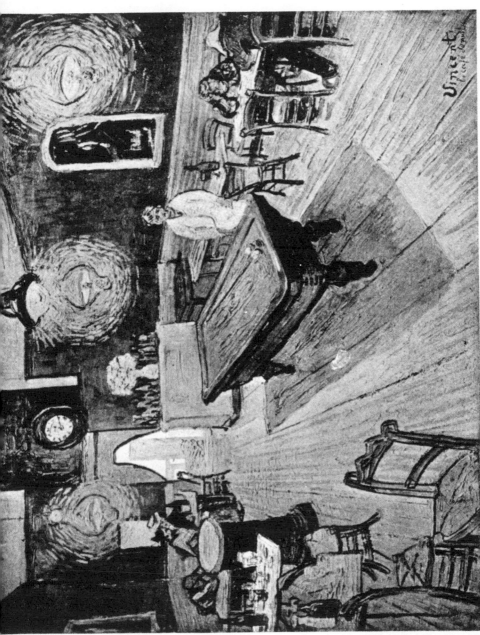

67

NIGHT CAFE

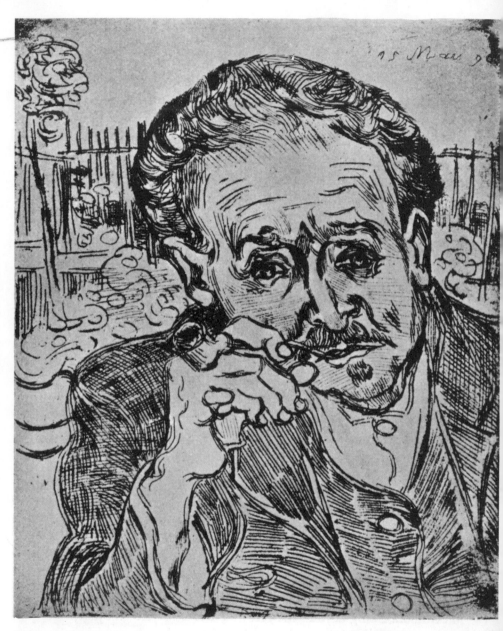

30

DR. GACHET (ETCHING)

be to miss its salient characteristic—its unexampled rapidity of expansion.

That comes above all in his last two years. His isolation in the South, his confinement in mad-houses, nothing holds him back in an advance whose passionate swiftness is equalled only by the logic with which he guides his course. If today, when we are to some extent able to judge a man's sanity from his words, Vincent's letters are the absolute refutation of any charge of fundamental unsoundness in his mind, the time is not far off when the painting itself will stand, for every intelligent man, as it does for artists and many art lovers at the present moment, as a thing not merely sane, but triumphant in its vindication of human dignity. It is by art more than by anything else that man asserts his position as the one among all the animals to see beyond material horizons.

The story of van Gogh resembling so much the story of Rembrandt, as we noted previously, is to some extent the story of all artists. We think of Michael Angelo in his position at the apogee of the Renaissance, and imagine that his lot was a happier one than that of the two Dutch painters. But read the story of the building of St. Peter's in Le Corbusier's laconic words: "Michael Angelo carried through the apses and the drum of the cupola. Then the rest fell into barbarous hands, everything was annihilated. Humanity lost one of the capital works of the mind. If one thinks of Michael Angelo perceiving the disaster, it is a frightful drama that unveils itself."

Only artists realize such things at all clearly, but humanity as a whole is the source of their ideas and so the works they produce redound to the credit of all men, slow as they are to understand them. Doubtless it was with some such grasp of the common origin of the art impulse that van Gogh made his plea for carrying it out in common. Going beyond that, he had dreams of the enjoyment of art by all men, for in one place at least he speaks of producing for the masses, since the rich picture-buyer is generally so unworthy

49

and accepts art on the snobbish basis of reputation and money value, instead of on its real value.

But Vincent's impatient mind leaped over the experience of art that will be needed before the masses can appreciate things at the time when they are done. Nothing proves that the people of the Gothic time looked on the cathedral as more than a statement of religious zeal. Were it conceivable to show those men a modern church, devoid of any art value—as all imitations are—but lit with electricity and served with the other conveniences of our time, it might well be that the thirteenth century public would be misled about its art as woefully as the nineteenth century public failed to get the joy of the great things done in its midst. The difference between the two periods is probably less a matter of creative ability or understanding than one of absence from the earlier time of a misleading "official" art.

As modern conditions render appreciation of art in common a chimera, at least for the present, so Vincent was ahead of his time— (for how long?)—in his scheme of production in common. There remains the third, and timeless, matter of the common source of art and, the impression of strangeness that van Gogh had for nearly all at the beginning, being almost dissipated, we may accept at something like face value the admiration that now goes out to his painting. In moments of vexation one may say that the crowds now going to see the work we are engaged on are made up of the same people who herded in to gape at the Sorolla pictures, twenty-five years ago. But if the public did gobble down those inferior things, we need not despair of progress,—of the growth of a solider nucleus of understanding, even amid crowds intent above all on the sensational. And infinitely less need we fear that art has weakened in its rôle of giving us a place apart among the animals. The bee with his architecture, the bird with his marvels of form and color do not offer even a hint of the thing that man creates—and cherishes, all evidence to the contrary notwithstanding.

One last matter of theory,—as regards that expressiveness which

develops so powerfully in van Gogh's last two years. He tells us through the letters to Theo of the ideas that were associated in his mind with the scenes he painted and the figures in them. The great Christian symbols of the sower and the reaper are to the fore in his mind as he paints the peasants around St. Rémy engaged in actual sowing and reaping. The colors burn as his thought burns,—as the thought of the early centuries of Christianity burned with its new-found fire. The dark lines that bound the face of that woman of Arles are like the dark lines around the figures in a great mosaic of Ravenna; the spots of pure color which give such resonance to the work seem more than paint—one imagines that lapis lazuli or the other precious materials that the enameler pours, molten, into his cells of gold would be needed for such an effect, as they were when the great reliquaries, pendants and crosses were made. Vincent does indeed seem, for all his modernity, to orient us in the centuries of faith, and his words—for example about the evil he would portray in the atmosphere of the *Café de Nuit*—might easily be taken as conclusive evidence in their favor by adherents of a literary art (such as the Communists are trying to revive, in Russia and other places, as a political instrument).

But van Gogh himself refutes any such idea. First of all, people who are accustomed to painting can see that, whatever the thought in the artist's mind about the aura of human interest around that room with the billiard table, the effect is produced by certain relationships of red, green and yellow, which are arrived at by observation of the light of the lamps falling on various objects and people. The shadow of the table, for example, and the reflection from the yellow floor back into the dark wood of the underside of the table, are stupendous examples of observation as humble as the artist once bestowed on the Dutch peasant who posed for him; but it is observation illuminated by the science due to his years in Paris. The effect is as dependent on the means as the divine voice of the flute in Bach's *Magnificat* is dependent on a column of air vibrating in a wooden tube of given lengths.

51

But the spirit that determines these relationships, that causes the selection of just these lines and colors, and no others, some one objects, does not this spirit go beyond the narrow world of the aesthete? It does, and his world is narrow, I cheerfully admit, taking him to be the man who divorces form and color from idea in order to revel in them for themselves.

But he is no more wrong than the person who tries to profit by the other element in the divorce—the idea unsupported by the form. And on this score, no longer relying on the evidence which painters see in the pictures, we may base our argument on a passage of van Gogh's writing. In a letter to Bernard, of the last months of his life, there is a passage which seems to me to take away all chance of the support from our artist that has been claimed by those who would see in him a protagonist of "pure" expression. I faithfully follow van Gogh's word "abstraction" in translating the following lines, but as Cubism has given the word a totally different meaning from what it once had the reader must not fail to recall that abstraction was employed, fifty years ago, in the sense that we now say "a literary picture" in terms of reproach. Bernard had sent on some photographs of his work, and van Gogh is discussing it.

"What I should like to see from you are things like the picture of yours that Gauguin has, of the Bretonne women walking in the meadows, so beautiful in the sense of order you gave to it, so naïvely distinguished in the color. And now you exchange that for what is (I am forced to say it) artificial and affected. . . . [In another picture Vincent liked] the girl's hair is, I suppose, a color-note rendered necessary as a complementary for the white dress; black if the clothing is white, orange if the clothing is blue. But I just said to myself, what a simple subject, and how little he needs in order to achieve elegance. . . . The *Christ Bearing His Cross* is atrocious. Is there any harmony to the spots of color in that?

"When Gauguin was at Arles, as you know, I let myself turn to abstraction, once or twice . . . and at that time abstract painting seemed to me to offer a charming path. But it is a land of sorcery,

52

that, my good friend! and one quickly finds oneself standing before a wall.

"I do not deny that, after a lifetime filled with research, with hand-to-hand battling with nature, one may take a chance at such things; but for my part, I don't want to bother my head with them. This whole year I have been digging away at nature, hardly giving a thought to Impressionism or one thing or another. However, one more time, I let myself go, making the stars in the sky too big, and again the thing was a failure; I've had enough of that business.

"And so I am working at present among the olive trees, [he underlines the last word, Bernard having sent him a photograph of a *Christ in the Garden of Olives,* of his own]; I seek out the varying effects of a gray sky against yellow earth, with a note of black-green in the foliage; another time, the earth and the foliage are streaked with violet against a yellow sky; then again the earth will be of red ochre and the sky of a greenish pink. And I tell you that that interests me more than the abstractions mentioned above."

As van Gogh makes no objection to a picture with a religious or similar subject but indeed continues to paint them himself, as he had offered a grandiose explanation drawn from the Christ story for one of his paintings of the wheat-field but a short time before, it is clear that his reproaches to Bernard are caused not by the presence of ideas in the picture, but by the absence of a structure of form and color sufficient to sustain the meaning of the work. "The *Christ Bearing the Cross*—is there any harmony to the spots of color in that?" It is not an aesthete who utters these words, but a Christian and an artist who, by his own example—whether in color or in the incomparable drawings of this time—proves that the qualities of the painter are what count, and that we cannot supply their lack by "abstraction" (literary values, to give one more reminder of his meaning for the word).

In another letter to Bernard he gives a fuller explanation of his ideal. "You see, I am not much of an eccentric; a Greek statue, a peasant by Millet, a Dutch portrait, a nude woman by Courbet or

53

Degas—those calm and modelled perfections cause any number of other things—the Primitives as well as the Japanese—to look like calligraphy. Such handwriting is endlessly interesting to me, but a thing that is complete, a perfection, renders the infinite tangible."

To many and many a work of his own, in the last year or two of his life, the words we have just heard from him may justly be applied. They are perfections, and so render the infinite within himself accessible to other men. And being perfect things we may take them as giving a meaning to words of Gleizes and Metzinger somewhat different from the one which those painters intended when writing their book called *Cubism*. With reference to Cézanne they say, "it is unfitting to compare him with van Gogh." It is, indeed, and not simply because Cézanne is the greater artist, but because each of the two men is so complete in himself that it would be mere deformation to try to make their lives run parallel.

To introduce a quotation from Delacroix that has meant much to me: "Parallel lines are monsters." And Vincent knows that between himself and the glorious ancestors of his school the lines of connection are not parallel, but continuing. In the final and greatest evolution of his color he gets again to modulations of a very few tones. And so we are reminded of that early sensibility of the retina which, in his days in Holland, had permitted him to say that Frans Hals has twenty-seven varieties of black! It is such fineness of perception which one sees, for example, in van Gogh's *l'Arlésienne* of the Bakwin collection, and which causes one to date the picture at the very end of his life, a year and a half later than the other versions of the subject.

Again continuing, instead of paralleling the effort of the old masters, is Vincent's use of perspective. He gives one more example of the element as a thing for the artist, as opposed to the scientist. And thereby he takes his place beside van Goyen, de Koninck, and perhaps especially Seghers, among the great Dutchmen of the old time, whom he strongly resembles both in his seeing of wide stretches of flat country and his means—line or color—for representing it.

54

As he carries on so well the message of the past, it is but logical that he should have been a clue to the future for the masters of the next generation. Matisse learns enormously from van Gogh, and makes no secret of it in his work. And—to give one more personal memory—I recall seeing a group of brilliantly colored pictures at a gallery in Paris and being unable to identify them. They were evidently by a man of very important talent—much akin in manner and tonality to van Gogh. But who was he? Finally, giving up the riddle, I looked at the signature. It was that of Derain, and the date (one wishes all pictures bore their date) told that these were from the very early years of the man who, so often an influence on others, was here accepting influence. The fact becomes the more significant when we remember that the color was so different from the austere browns and blacks that Derain has accustomed us to in later years.

And to cite one more homage from a leading artist of the present day, the audacious quality in Picasso, the quality which has imposed the authority of his brilliant mind a hundred times, is nowhere better seen than in his words about the man we have been studying: "Why do the Dutch mourn for Rembrandt? They have van Gogh."